Clip Art for

Sundays and Solemnities

Julie Lonneman

LTP

LITURGY
TRAINING
PUBLICATIONS

Duplicating the Art in This Book

LICENSE AGREEMENT

The original purchaser (individual or institution) has the right to use any of the artwork contained in this book and CD, without charge and without further permission, subject to the following terms and conditions:

Copyright notice and credit line

Whenever the art is reproduced, and on each product containing a reproduction of the art, you must print the following copyright notice and credit line in close proximity to the art, or in a usual and customary place: © 2003 Liturgy Training Publications, art by Julie Lonneman.

The following uses are not allowed without first applying for an additional license from LTP:

Materials that are to be sold (apart from a limited fundraising campaign)

The art may not be used in any materials that are to be sold, apart from a fundraising campaign of limited duration. See below for more information on fundraising uses.

Permanent or quasi-permanent installations

The art may not be used as part of a permanent or quasi-permanent installation. The art may not be used in mosaic tiles, stained glass windows, altars, pews, chairs, and other furniture or as part of any building structure. The art may not be used in banners, signs, plaques, posters, and the like which are expected to be in use for, or have an expected life of, more than one year.

Logos and trademarks

The art may not be used as part of the logo, trademark, or other identifying mark of any institution, association, organization, or program, regardless of whether it is non-profit or not-for-profit.

The following uses do not require an additional license from LTP except as indicated:

Materials that are to be sold as part of a limited fundraising campaign

The art may be used in a product that is intended to be sold solely as part of a limited-duration fundraising campaign by a non-profit or a not-for-profit organization, as long as a cumulative total of no more than 2,000 units is produced.

Gift and promotional items

The art may be used in creating gift and promotional items (such as coffee mugs, t-shirts, jewelry, ribbons, bookmarks, and the like), as long as the items are given away without cost and as long as a cumulative total of no more than 2,000 units is produced.

Electronic uses

The art may be used on your personal website, and on the website of a non-profit or a not-for-profit organization, as long as downloading and reuse of the art is strictly prohibited, and as long as steps are taken by those responsible for the website to prevent such downloading and reuse. In no case may the art be put on a website at a higher resolution than 96dpi. Neither the CD nor its individual files may be copied or resold by any individual or organization, or become part of any electronic product other than specified above.

Temporary installations and products

The art may be used on banners, posters, signs, placards, and the like as long as these are not expected to be, and in fact are not, in use for a cumulative period of more than one year.

Slides and transparencies

The art may be made into slides and transparencies for use in connection with programs with purposes such as teaching and instruction, as long as there is no fee or other charge for admission to such programs, and the program is not sponsored or delivered by any commercial venture. No more than 20 images may be used in the same program or presentation.

If you want to use the art in any way that is not allowed by the above provisions, you may apply for an additional license by contacting the following: Design Manager, Liturgy Training Publications, 1800 North Hermitage Avenue, Chicago IL 60622; 773-486-8970.

CLIP ART FOR SUNDAYS AND SOLEMNITIES © 2003 Archdiocese of Chicago: Liturgy Training Publications, 1800 North Hermitage Avenue, Chicago IL 60622-1101; 1-800-933-1800, fax 1-800-933-7094, orders@ltp.org; www.ltp.org. All rights reserved. See our website at www.ltp.org.

This book was edited by David Philippart. Carol Mycio was the production editor. The design is by Larry Cope, and the typesetting was done by Mark Hollopeter in Frutiger and Nuptial Script.

Printed in Canada.

Library of Congress Control Number: 2003104040

ISBN 1-56854-489-8
CLIPSS

Table of Contents

First Sunday of Advent

YEAR A

Romans 13:12

The night is far spent;
the day draws near.

01_ADVENT_1_A.TIF

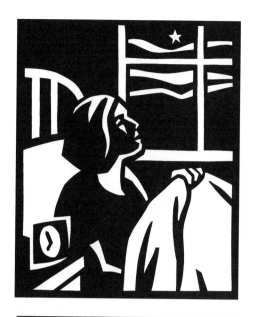

YEAR B

Isaiah 63:17

Why do you let us
wander, O Lord,
from your ways?

01_ADVENT_1_B.TIF

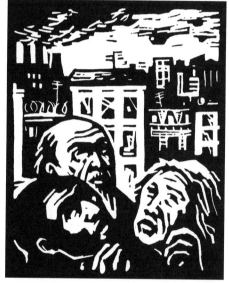

YEAR C

Jeremiah 33:15

I will raise up for David
a just shoot.

01_ADVENT_1_C.TIF

First Sunday of Advent

1

Second Sunday of Advent

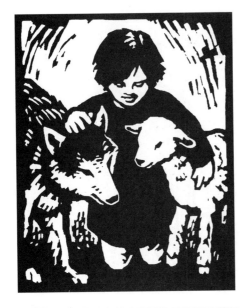

YEAR A

Isaiah 11:6

Then the wolf shall be
a guest of the lamb,
with a little child
to guide them.

02_ADVENT_2_A.TIF

YEAR B

Isaiah 40:2

Her service is at an end;
her guilt is expiated.

02_ADVENT_2_B.TIF

YEAR C

Luke 3:4

Prepare the way
of the Lord.

02_ADVENT_2_C.TIF

YEAR A

James 5:7

See how the farmer awaits the precious yield of the soil.

03_ADVENT_3_A.TIF

YEAR B

Isaiah 61:1

He has sent me to heal the brokenhearted.

03_ADVENT_3_B.TIF

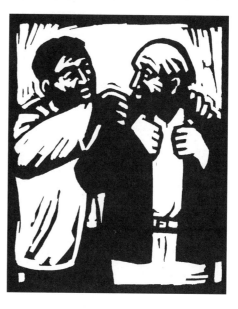

YEAR C

Luke 3:11

Whoever has two coats should share with the person who has none.

03_ADVENT_3_C.TIF

Fourth Sunday of Advent

YEAR A

Matthew 1:23

The virgin shall be
with child.

04_ADVENT_4_A.TIF

YEAR B

Luke 1:38

Be it done to me
according to your word.

04_ADVENT_4_B.TIF

YEAR C

Luke 1:42

Blessed are you
among women.

04_ADVENT_4_C.TIF

DECEMBER 8

Luke 1:45

Blessed is she who
believed that what was
spoken to her by the
Lord would be fulfilled.

05_IMMACULATE_ABC.TIF

Christmas

YEAR A, B, AND C

Luke 2:9–10

An angel appeared before the shepherds, saying, "Do not be afraid; I bring you good news."

06_CHRISTMAS_1.TIF

YEAR A, B, AND C

Psalm 96:11

Let the heavens be glad; the earth rejoice.

06_CHRISTMAS_2.TIF

YEAR A, B, AND C

Luke 2:7

She gave birth to her firstborn son and wrapped him in swaddling clothes.

06_CHRISTMAS_3.TIF

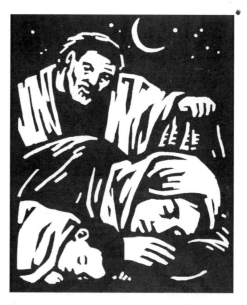

YEAR A

Matthew 2:13

Get up, awake the
child and his mother
and flee to Egypt.

07_FAMILY_1.TIF

YEARS A, B, AND C

Sirach 3:3–4

Those who honor their
father, atone for sins;
those who respect their
mother, store up treasures.

07_FAMILY_2.TIF

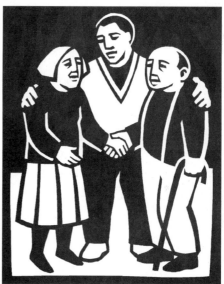

YEAR C

Luke 2:46

They found him in
the temple, sitting among
the teachers, listening
to them and asking them
questions.

07_FAMILY_3.TIF

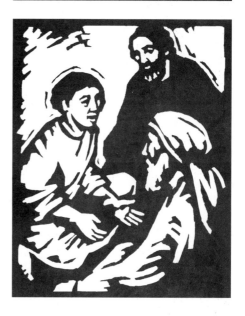

Mary, Mother of God

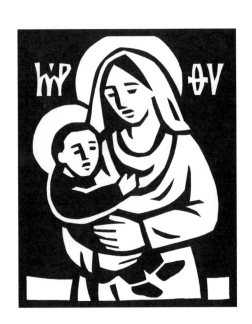

YEARS A, B, AND C

Galatians 4:4

When the fullness of time had come, God sent his Son, born of a woman.

08_MOTHER_ABC.TIF

YEARS A, B, AND C

Isaiah 60:1

Arise and shine;
your light has come.

09_EPIPHANY_A.TIF

YEARS A, B, AND C

Matthew 2:11

They paid him homage.

09_EPIPHANY_B.TIF

YEARS A, B, AND C

Matthew 2:11

They saw the child
with Mary, his mother.

09_EPIPHANY_C.TIF

Baptism of the Lord

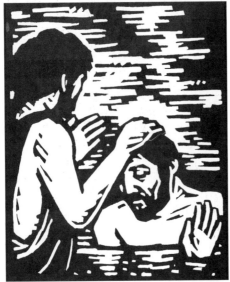

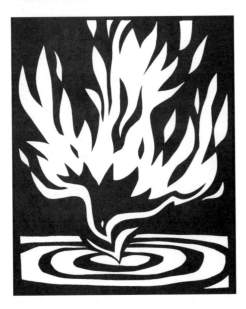

YEAR A

Isaiah 42:2

Here is my servant,
my chosen one with
whom I am well pleased.

10_BAPTISM_A.TIF

YEAR B

Mark 1:9

Jesus came from
Nazareth of Galilee
and was baptized
by John in Jordan.

10_BAPTISM_B.TIF

YEAR C

Luke 3:16

You will be baptized with
the Holy Spirit and fire.

10_BAPTISM_C.TIF

YEARS A, B, AND C

Joel 2:12

Yet even now return to
me with your whole heart.

11_WEDNESDAY_ABC.TIF

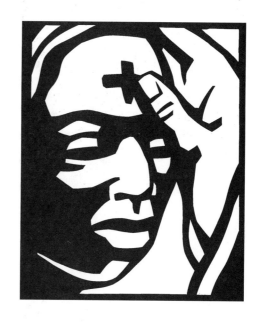

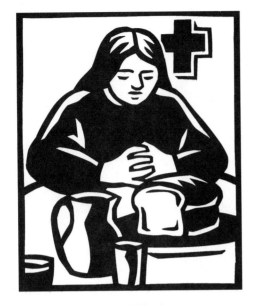

YEAR A

Matthew 4:4

Not by bread alone are you to live but by every utterance that comes from the mouth of God.

12_LENT_1_A.TIF

YEAR B

Mark 1:14–15

Jesus came to Galilee proclaiming the gospel: "The reign of God is at hand!"

12_LENT_1_B.TIF

YEAR C

Deuteronomy 26:10

You shall bow down in God's presence.

12_LENT_1_C.TIF

YEAR A

Matthew 17:2

Christ's face became
as dazzling as the sun,
his clothes as radiant
as light.

13_LENT_2_A.TIF

YEAR B

Genesis 22:12

Do not lay your hand
on the boy!

13_LENT_2_B.TIF

YEAR C

Genesis 15:5

Count the stars if you can.

13_LENT_2_C.TIF

Third Sunday of Lent

YEAR A

John 4:14

Whoever drinks the water I shall give will never thirst.

14_LENT_3_A.TIF

YEAR B

John 2:16

Stop making my Father's house a marketplace.

14_LENT_3_B.TIF

YEAR C

Luke 13:9

Leave it for another year; then perhaps it will bear fruit.

14_LENT_3_B.TIF

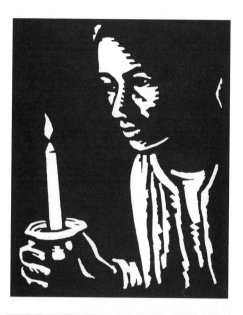

YEAR A

Ephesians 5:8

Now you are light in the Lord.

15_LENT_4_A.TIF

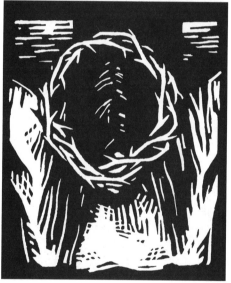

YEAR B

John 3:16

For God so loved the world that he gave his only son.

15_LENT_4_B.TIF

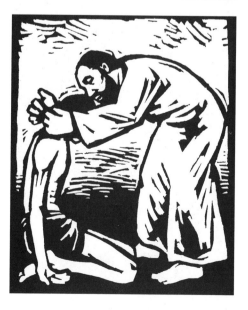

YEAR C

Luke 15:20

His father was filled with compassion.

15_LENT_4_C.TIF

Fifth Sunday of Lent

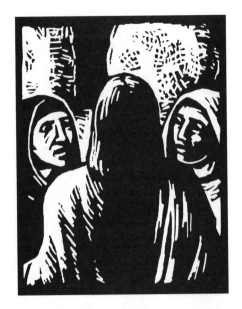

YEAR A

John 11:43

Lazarus, come out!

16_LENT_5_A.TIF

YEAR B

John 12:24

If it dies, it produces much fruit.

16_LENT_5_B.TIF

YEAR C

John 8:11

Nor do I condemn you.

16_LENT_5_C.TIF

YEAR A

Matthew 21:5

Your king comes to you,
meek and riding on an ass.

17_PASSION_A.TIF

YEAR B

Mark 11:10; 15:14

Hosanna in the highest!
Crucify him!

17_PASSION_B.TIF

YEAR C

Luke 23:29

The days are coming
when people will say,
"Blessed are the barren."

17_PASSION_C.TIF

Holy Thursday, Good Friday

YEARS A, B, AND C

1 Corinthians 11:24

Do this in remembrance of me.

18_THURSDAY_ABC.TIF

YEARS A, B, AND C

John 18:36

My kingdom is not of this world.

18_FRIDAY_ABC.TIF

YEAR A

Matthew 28:6

He is not here for he has been raised just as he said.

19_EASTER_A.TIF

YEAR B

Mark 16:8

They went out and fled from the tomb for terror and amazement had seized them.

19_EASTER_B.TIF

YEAR C

John 20:8

The disciples saw and believed.

19_EASTER_C.TIF

Second Sunday of Easter

YEAR A

Acts 2:42

They devoted themselves to breaking bread in their homes.

20_EASTER_2_A.TIF

YEAR B

John 20:19

Peace be with you.

20_EASTER_2_B.TIF

YEAR C

Revelation 1:18

I once was dead, but now I am alive forever.

20_EASTER_2_C.TIF

YEAR A

Luke 24:32

Were not our hearts
burning within us?

21_EASTER_3_A.TIF

YEAR B

Luke 24:39

Look at my hands and
my feet!

21_EASTER_3_B.TIF

YEAR C

John 21:12

Come, have
your breakfast.

21_EASTER_3_C.TIF

Fourth Sunday of Easter

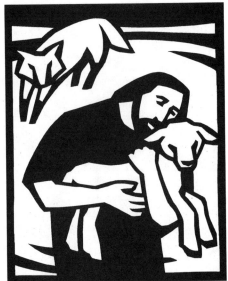

YEAR A

Acts 2:39

The promise is made to you.

22_EASTER_4_A.TIF

YEAR B

John 10:11

I am the good shepherd.

22_EASTER_4_B.TIF

YEAR C

Revelation 7:9

There was a multitude standing before the Lamb with palm branches.

22_EASTER_4_C.TIF

YEAR A

1 Peter 2:9

You are a people called out of darkness into wonderful light.

23_EASTER_5_A.TIF

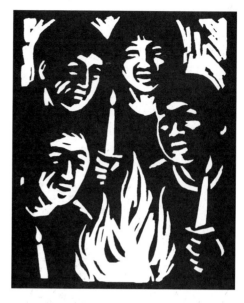

YEAR B

John 15:5

Whoever remains in me will bear much fruit.

23_EASTER_5_B.TIF

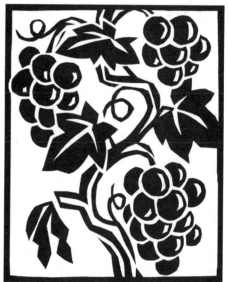

YEAR C

Revelation 21:5

See, I make all things new.

23_EASTER_5_C.TIF

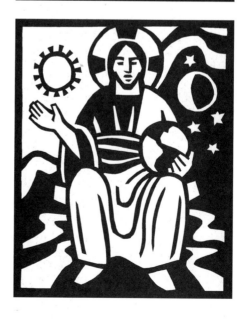

Sixth Sunday of Easter

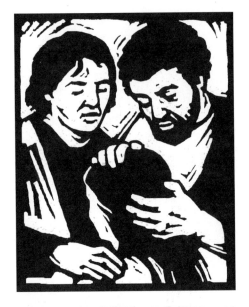

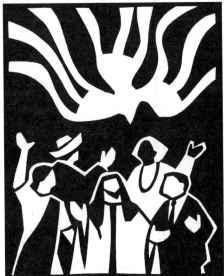

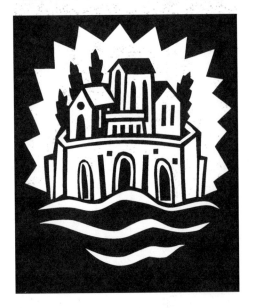

YEAR A

Acts 8:14–15

Peter and John prayed for them that they might receive the Holy Spirit.

24_EASTER_6_A.TIF

YEAR B

Acts 10:35

In every nation whoever fears God is acceptable to God.

24_EASTER_6_B.TIF

YEAR C

Revelation 21:10

I saw the holy city, Jerusalem, gleaming with splendor.

24_EASTER_6_C.TIF

YEARS A, B, AND C

Acts 1:11

Why are you looking up
to heaven?

25_ASCENSION_ABC.TIF

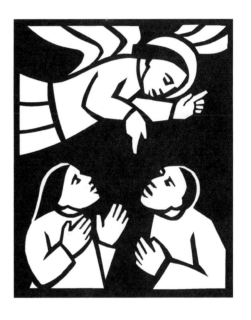

Seventh Sunday of Easter

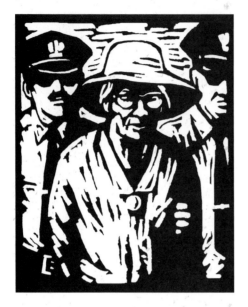

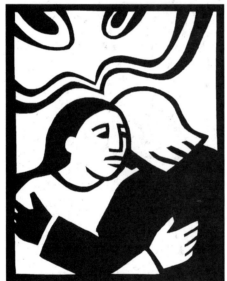

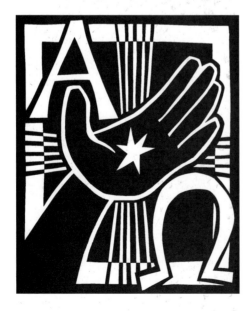

YEAR A

1 Peter 4:16

Whoever is made to suffer as a Christian should not be ashamed but glorify God.

26_EASTER_7_A.TIF

YEAR B

1 John 4:12

If we love one another, God remains in us.

26_EASTER_7_B.TIF

YEAR C

Revelation 22:13

I am the Alpha and the Omega.

26_EASTER_7_C.TIF

YEAR A

Psalm 104:30

Send forth your spirit and renew the face of the earth.

27_PENTECOST_A.TIF

YEAR B

Galatians 5:16

Live by the Spirit and you will certainly not gratify the desires of the flesh.

27_PENTECOST_B.TIF

YEAR C

John 20:22

He breathed on them and said, "Receive the Holy Spirit."

27_PENTECOST_C.TIF

YEAR A

2 Corinthians 13:11

Live in peace with one another and the God of peace will be with you.

28_TRINITY_A.TIF

YEAR B

Matthew 28:19

Baptized in the name of the Father, and of the Son, and of the Holy Sprit.

28_TRINITY_B.TIF

YEAR C

Romans 5:5

Our hearts are filled with God's love through the Holy Spirit.

28_TRINITY_C.TIF

YEAR A

1 Corinthians 10:17

We are one body
in Christ.

29_BODY_CHRIST_A.TIF

YEAR B

Mark 14:22

Jesus took a loaf of bread,
and after blessing it he
broke it, gave it to them,
saying, "Take; this is
my body."

29_BODY_CHRIST_B.TIF

YEAR C

Psalm 116:13

I will take the cup of
salvation and call on
the name of the Lord.

29_BODY_CHRIST_C.TIF

Sacred Heart of Jesus

YEARS A, B, AND C

Ezekiel 34:11–16

I will look after my flock.

30_SACRED_HEART_ABC.TIF

Second Sunday in Ordinary Time

YEAR A

John 1:29

Look there! The Lamb of God who takes away the sin of the world.

31_ORDINARY_2_A.TIF

YEAR B

1 Corinthians 6:20

Glorify God in your body.

31_ORDINARY_2_B.TIF

YEAR C

Isaiah 62:5

As a groom rejoices in his bride, so shall your God rejoice in you.

31_ORDINARY_2_C.TIF

Third Sunday in Ordinary Time

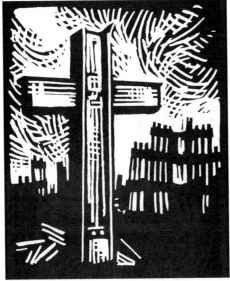

YEAR A

Isaiah 9:1

The people who have walked in darkness have seen a great light.

32_ORDINARY_3_A.TIF

YEAR B

1 Corinthians 7:31

The world in its present form is passing away.

32_ORDINARY_3_B.TIF

YEAR C

Luke 4:18

He has anointed me to bring glad tidings.

32_ORDINARY_3_C.TIF

YEAR A

1 Corinthians 1:27

God chose the weak
of the world to shame
the strong.

33_ORDINARY_4_A.TIF

YEAR B

Mark 1:22

Jesus taught as one
having authority.

33_ORDINARY_4_B.TIF

YEAR C

Luke 4:29

They rose up and drove
Jesus out of town.

33_ORDINARY_4_C.TIF

33

Fifth Sunday in Ordinary Time

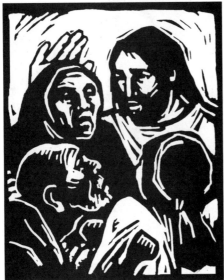

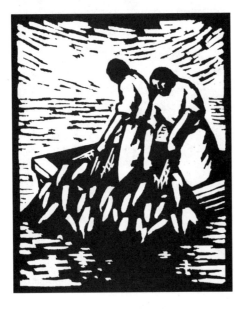

YEAR A

Matthew 5:16

Your light must shine before others.

34_ORDINARY_5_A.TIF

YEAR B

Mark 1:34

He cured many who were sick.

34_ORDINARY_5_B.TIF

YEAR C

Luke 5:6

They caught a great number of fish.

34_ORDINARY_5_C.TIF

YEAR A

Sirach 15:17

Before us are life
and death; whichever
we choose shall be
given to us.

35_ORDINARY_6_A.TIF

YEAR B

Mark 1:45

He remained outside
in deserted places, and
people kept coming
to him.

35_ORDINARY_6_B.TIF

YEAR C

Luke 6:20

Blessed are you who are
poor, for the kingdom of
God is yours.

35_ORDINARY_6_C.TIF

Seventh Sunday in Ordinary Time

YEAR A

Matthew 5:44

Love your enemies,
and pray for those
who persecute you.

36_ORDINARY_7_A.TIF

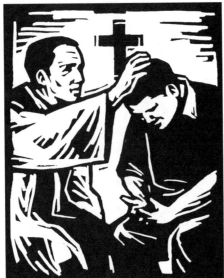

YEAR B

Isaiah 43:25

Your sins I remember
no more.

36_ORDINARY_7_B.TIF

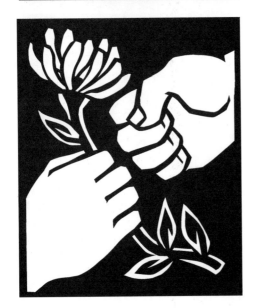

YEAR C

Luke 6:27

Love your enemies.

36_ORDINARY_7_C.TIF

YEAR A

Matthew 6:28

Learn from the way
the wild flowers grow.

37_ORDINARY_8_A.TIF

YEAR B

2 Corinthians 3:6

The letter brings death
but the Spirit gives life.

37_ORDINARY_8_B.TIF

YEAR C

Luke 6:45

A good person out
of a store of goodness
produces good.

37_ORDINARY_8_C.TIF

Ninth Sunday in Ordinary Time

YEAR A

Matthew 7:24

Everyone who listens to these words of mine and acts on them will be like a wise man who built his house on rock.

38_ORDINARY_9_A.TIF

YEAR B

2 Corinthians 4:10

We carry in our bodies the death of the Lord.

38_ORDINARY_9_B.TIF

YEAR C

1 Kings 8:43

May all the peoples of the earth know your name.

38_ORDINARY_9_C.TIF

YEAR A

Hosea 6:6

It is love that I desire, not sacrifice, and knowledge of God rather than holocausts.

39_ORDINARY_10_A.TIF

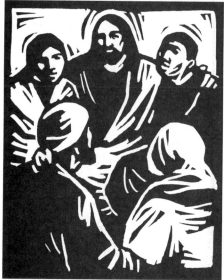

YEAR B

Mark 3:35

Whoever does the will of God is my brother and sister and mother.

39_ORDINARY_10_B.TIF

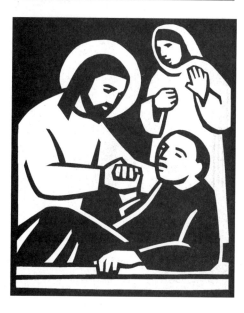

YEAR C

Luke 7:14

Young man, I tell you, arise!

39_ORDINARY_10_C.TIF

Eleventh Sunday in Ordinary Time

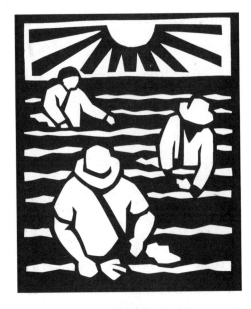

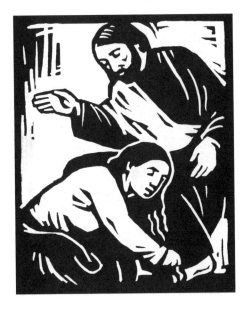

YEAR A

Matthew 9:38

Ask the master of the harvest to send out laborers.

40_ORDINARY_11_A.TIF

YEAR B

Ezekiel 17:23

It shall put forth branches and bear fruit and become a majestic cedar.

40_ORDINARY_11_B.TIF

YEAR C

Luke 7:47

Her many sins have been forgiven; hence, she has shown great love.

40_ORDINARY_11_C.TIF

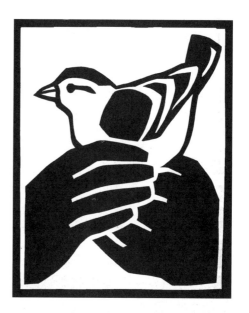

YEAR A

Matthew 10:31

Do not be afraid; you are worth more than many sparrows.

41_ORDINARY_12_A.TIF

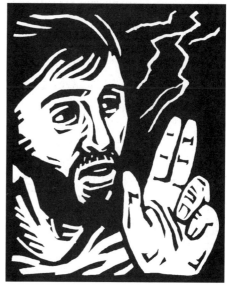

YEAR B

Mark 4:41

Who then is this whom even wind and sea obey?

41_ORDINARY_12_B.TIF

YEAR C

Zechariah 12:10

I will pour out a spirit of grace and petition.

41_ORDINARY_12_C.TIF

41

Thirteenth Sunday in Ordinary Time

YEAR A

Romans 6:3

We who were baptized into Christ Jesus were baptized into his death.

42_ORDINARY_13_A.TIF

YEAR B

2 Corinthians 8:15

Whoever had much did not have more, and whoever had less did not have less.

42_ORDINARY_13_B.TIF

YEAR C

Luke 9:62

No one who sets a hand to the plow and looks back is fit for the reign of God.

42_ORDINARY_13_C.TIF

YEAR A

Matthew 11:28

Come to me, all you who labor and are burdened, and I will give you rest.

43_ORDINARY_14_A.TIF

YEAR B

2 Corinthians 12:10

When I am weak, then I am strong.

43_ORDINARY_14_B.TIF

YEAR C

Isaiah 66:13

As a mother comforts her child, so I comfort you.

43_ORDINARY_14_C.TIF

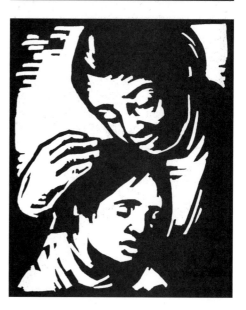

Fifteenth Sunday in Ordinary Time

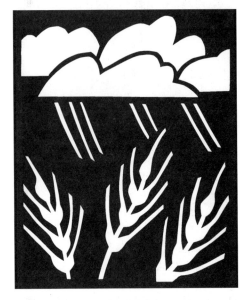

YEAR A

Isaiah 55:11

My word shall not return to me void, but shall do my will, achieving the end for which I sent it.

44_ORDINARY_15_A.TIF

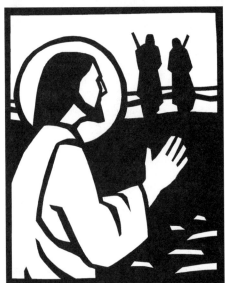

YEAR B

Mark 6:7

Jesus sent them out two by two.

44_ORDINARY_15_B.TIF

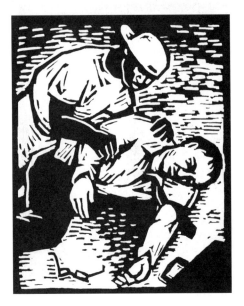

YEAR C

Luke 10:37

Go and do likewise.

44_ORDINARY_15_C.TIF

YEAR A

Matthew 13:32

It is the smallest of all the seeds, yet when full grown it is the largest of plants.

45_ORDINARY_16_A.TIF

YEAR B

Jeremiah 23:3

I myself will gather my flock.

45_ORDINARY_16_B.TIF

YEAR C

Luke 10:42

There is need of only one thing.

45_ORDINARY_16_C.TIF

Seventeenth Sunday in Ordinary Time

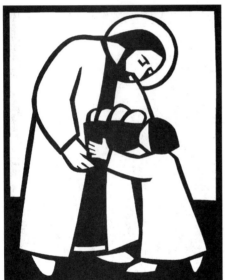

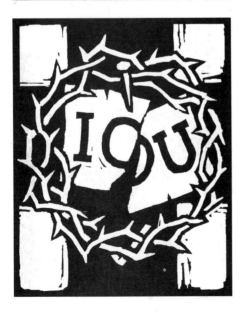

YEAR A

Matthew 13:44

The reign of heaven is like a treasure buried in a field, which a person finds and sells all to buy that field.

46_ORDINARY_17_A.TIF

YEAR B

John 6:9

There is a boy here who has five barley loaves and two fish.

46_ORDINARY_17_B.TIF

YEAR C

Colossians 2:13–14

Christ has forgiven our transgressions, obliterated the bond against us, nailing it to the tree.

46_ORDINARY_17_C.TIF

YEAR A

Isaiah 55:1

All you who are thirsty, come to the water.

47_ORDINARY_18_A.TIF

YEAR B

John 6:35

Whoever believes in me will never thirst.

47_ORDINARY_18_B.TIF

YEAR C

Ecclesiastes 2:22

What profit comes from toil and anxiety?

47_ORDINARY_18_C.TIF

Nineteenth Sunday in Ordinary Time

YEAR A

Matthew 14:27

Take courage, it is I;
do not be afraid.

48_ORDINARY_19_A.TIF

YEAR B

John 6:51

The bread that I will give
is my flesh for the life
of the world.

48_ORDINARY_19_B.TIF

YEAR C

Wisdom 18:8

In this you glorified us
whom you summoned.

48_ORDINARY_19_C.TIF

YEAR A

Matthew 15:28

O woman, great is
your faith!

49_ORDINARY_20_A.TIF

YEAR B

Ephesians 5:18–19

Filled with the Spirit,
address one another
in psalms, hymns
and spiritual songs.

49_ORDINARY_20_B.TIF

YEAR C

Hebrews 12:1

Let us persevere in
running the race
that lies before us.

49_ORDINARY_20_C.TIF

Twenty-first Sunday in Ordinary Time

YEAR A

Matthew 16:19

I will give you the keys to the kingdom of heaven.

50_ORDINARY_21_A.TIF

YEAR B

Ephesians 5:21

Be subordinate to one another out of reverence to Christ.

50_ORDINARY_21_B.TIF

YEAR C

Hebrews 12:7

For what child is there that a father does not discipline?

50_ORDINARY_21_C.TIF

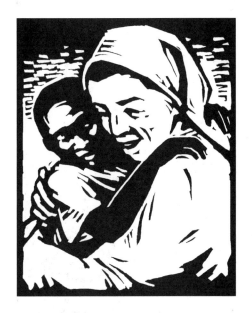

YEAR A

Matthew 16:25

Whoever loses one's life for my sake will find it.

51_ORDINARY_22_A.TIF

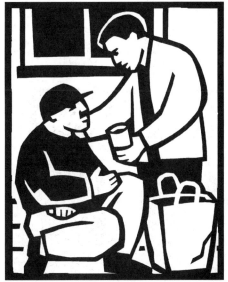

YEAR B

James 1:22

Be doers of the word and not hearers only.

51_ORDINARY_22_B.TIF

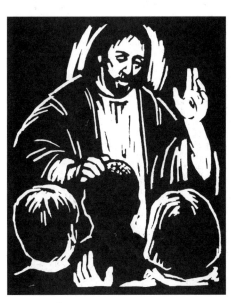

YEAR C

Hebrews 12:22, 24

You have approached Jesus, the mediator of a new covenant.

51_ORDINARY_22_C.TIF

Twenty-third Sunday in Ordinary Time

YEAR A

Matthew 18:20

Where two or more are
gathered in my name,
I am in the midst of them.

52_ORDINARY_23_A.TIF

YEAR B

Isaiah 35:5–6

Then will the eyes of
the blind be opened and
the lame leap like a stag.

52_ORDINARY_23_B.TIF

YEAR C

Wisdom 9:15

The earthen shelter
weighs down the mind
that has many concerns.

52_ORDINARY_23_C.TIF

YEAR A

Matthew 18:33

Should you not have had pity on your fellow servant, as I had pity on you?

53_ORDINARY_24_A.TIF

YEAR B

James 2:16

Keep warm and eat well.

53_ORDINARY_24_B.TIF

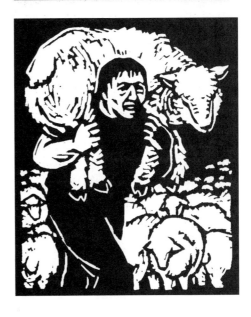

YEAR C

Luke 15:6

Rejoice with me because I have found my lost sheep.

53_ORDINARY_24_C.TIF

Twenty-fifth Sunday in Ordinary Time

YEAR A

Matthew 20:15

Are you envious because
I am generous?

54_ORDINARY_25_A.TIF

YEAR B

Mark 9:37

Whoever receives
one child such as this
receives me.

54_ORDINARY_25_B.TIF

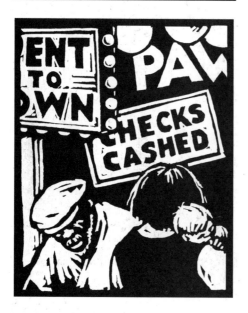

YEAR C

Amos 8:7

Never will I forget a thing
that they have done!

54_ORDINARY_25_C.TIF

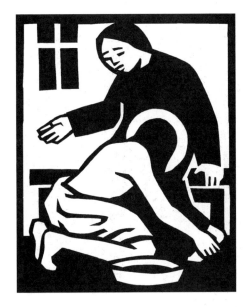

YEAR A

Philippians 2:7

Christ emptied himself, taking the nature of a slave.

55_ORDINARY_26_A.TIF

YEAR B

James 5:4

The cries of the harvesters have reached God's ears.

55_ORDINARY_26_B.TIF

YEAR C

Amos 6:7

Their wanton revelry shall be done away with.

55_ORDINARY_26_C.TIF

Twenty-seventh Sunday in Ordinary Time

YEAR A

Matthew 21:41

He will lease his vineyard to other tenants who will give him the produce at the proper times.

56_ORDINARY_27_A.TIF

YEAR B

Genesis 2:24

The two become one flesh.

56_ORDINARY_27_B.TIF

YEAR C

2 Timothy 1:8

Bear your share of the hardship for the gospel with the strength that comes from God.

56_ORDINARY_27_C.TIF

YEAR A

Isaiah 25:8

The Lord God will wipe
away the tears from
all faces.

57_ORDINARY_28_A.TIF

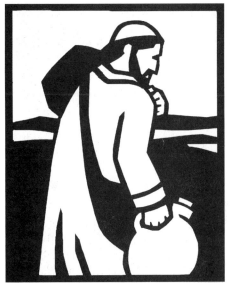

YEAR B

Mark 10:22

The young man went
away sad because
he had many possessions.

57_ORDINARY_28_B.TIF

YEAR C

2 Timothy 2:9

The word of God
is not chained.

57_ORDINARY_28_C.TIF

YEAR A

Matthew 22:21

Repay to Caesar what is Caesar's and to God what is God's.

58_ORDINARY_29_A.TIF

YEAR B

Isaiah 53:11

Through his suffering, my servant shall justify many.

58_ORDINARY_29_B.TIF

YEAR C

2 Timothy 4:2

Proclaim, convince, reprimand, encourage through all patience and teaching.

58_ORDINARY_29_C.TIF

YEAR A

Exodus 22:22

Those who cry out
to me I will hear for
I am compassionate.

59_ORDINARY_30_A.TIF

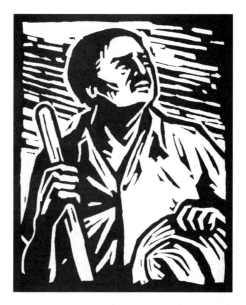

YEAR B

Mark 10:51

Master, I want to see.

59_ORDINARY_30_B.TIF

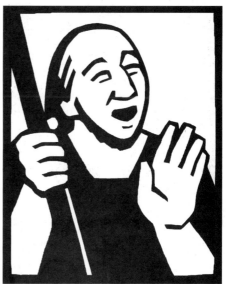

YEAR C

Luke 18:13

O God, be merciful to me,
a sinner.

59_ORDINARY_30_C.TIF

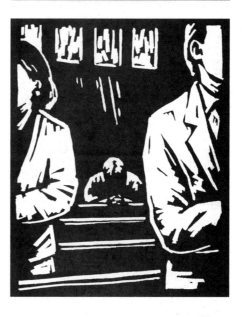

Thirty-first Sunday in Ordinary Time

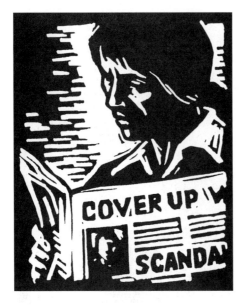

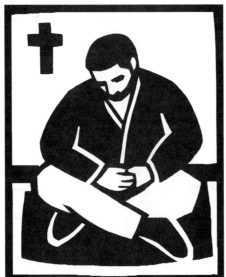

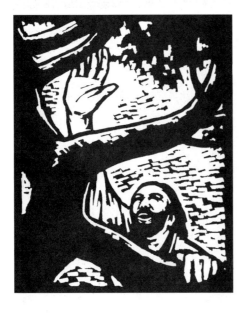

YEAR A

Malachi 2:8

You have turned aside from the way and have caused many to falter by your instruction.

60_ORDINARY_31_A.TIF

YEAR B

Deuteronomy 6:4

Love the Lord your God with all your heart and with all your soul and with all your strength.

60_ORDINARY_31_B.TIF

YEAR C

Luke 19:5

Come down quickly, for today I must stay at your house.

60_ORDINARY_31_C.TIF

YEAR A

Matthew 25:13

Stay awake for you know neither the day nor the hour.

61_ORDINARY_32_A.TIF

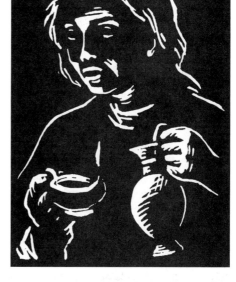

YEAR B

Mark 12:44

From her poverty she has contributed all she had.

61_ORDINARY_32_B.TIF

YEAR C

2 Thessalonians 3:5

May the Lord rule your hearts in the love of God and the constancy of Christ.

61_ORDINARY_32_C.TIF

Thirty-third Sunday in Ordinary Time

YEAR A

1 Thessalonians 5:5

All of you are children of the light and children of the day.

62_ORDINARY_33_A.TIF

YEAR B

Mark 13:24–25

In those days the powers in heaven shall be shaken.

62_ORDINARY_33_B.TIF

YEAR C

Malachi 3:20

The sun of justice will arise with healing in its wings.

62_ORDINARY_33_C.TIF

Christ the King
(Thirty-fourth Sunday in Ordinary Time)

YEAR A

Matthew 25:44

Lord, when did we see you hungry or thirsty or a stranger or naked or ill or in prison?

63_CHRIST_KING_A.TIF

YEAR B

Revelation 1:5–6

To him who loves us and has freed us by his blood be glory and power forever.

63_CHRIST_KING_B.TIF

YEAR C

Colossians 1:20

It pleased God to make absolute fullness reside in Christ, making peace through the blood of his cross.

63_CHRIST_KING_C.TIF

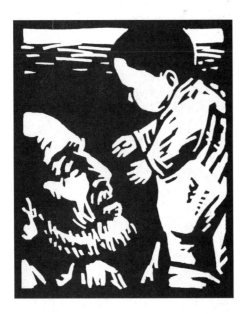

Presentation

FEBRUARY 2

Luke 2:28

Simeon took the child into his arms and praised God.

64_PRESENTATION_ABC.TIF

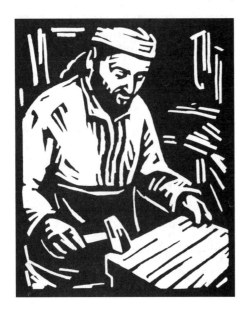

Saint Joseph

MARCH 19

Matthew 1:19

Joseph was a righteous man.

64_JOSEPH_ABC.TIF

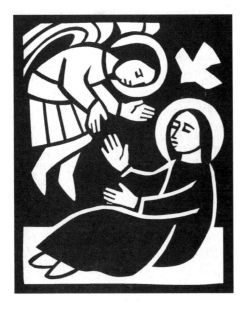

Annunciation

MARCH 25

Luke 1:28

Hail, full of grace.

64_ANNUNCIATION_ABC.TIF

Birth of John the Baptist

JUNE 24

Luke 1:60

He will be called "John."

65_BAPTIST_ABC.TIF

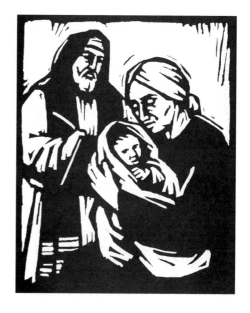

Saints Peter and Paul

JUNE 29

Psalm 19:4

Their voices are heard throughout all the earth; their words, to the end of the world.

65_PETER_PAUL_ABC.TIF

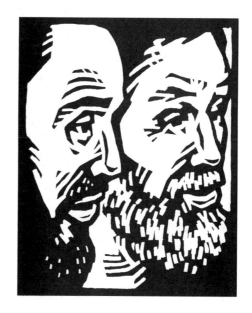

Transfiguration

AUGUST 6

Matthew 17:2

He shone like the sun.

65_TRANSFIGURATION_ABC.TIF

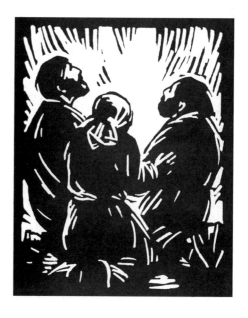

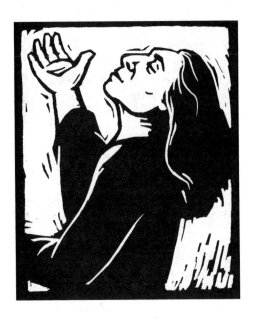

Assumption

AUGUST 15

Luke 1:46

My soul magnifies the Lord.

66_ASSUMPTION_ABC.TIF

Holy Cross

SEPTEMBER 14

John 3:14–15

The Son of Man must be lifted up so that whoever believes in him will have eternal life.

66_HOLY_CROSS_ABC.TIF

All Saints

NOVEMBER 1

Matthew 5:5

Blessed are the meek, for they will inherit the land.

66_ALL_SAINTS_ABC.TIF

All Souls

NOVEMBER 2

Romans 14:8

Whether we live
or whether we die,
we are the Lord's.

67_ALL_SOULS_ABC.TIF

Dedication of
the Lateran Basilica

NOVEMBER 9

1 Corinthians 3:16

You are the temple;
the spirit of God
dwells within you.

67_LATERAN_ABC.TIF

Our Lady
of Guadalupe

DECEMBER 12

Luke 1:52

He has thrown down
the rulers from their
thrones but lifted up
the lowly.

67_GUADALUPE_ABC.TIF

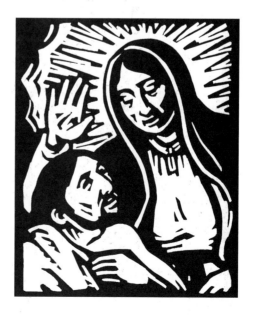

About the Artist

Julie Lonneman, a freelance illustrator, lives and works in urban Cincinnati, Ohio, where she maintains a studio. Her illustrations, focusing on themes of spirituality and social justice, have been published nationally and internationally. Julie's husband, Bill, is a nurse practitioner. They are the parents of two teenage girls.

How to Use the CD

CD-ROM INFORMATION
Contents of the CD-ROM
This CD-ROM contains 190 black and white images at a resolution of 600DPI, which will give you quality results whether you use a laser printer or a commercial printing establishment. In addition to the images, we have included a PDF file of the entire book. The images can be viewed in this format as they would in the book, with the help of Acrobat®, which can be downloaded free from the internet or installed from the CD-ROM.

SYSTEM REQUIREMENTS
Minimum Windows® System Requirements
Intel® 486 or compatible computer (Pentium® recommended) • Windows® 95, Windows® 98, Windows® 2000 or Windows NT® 4.0 or higher • 16 MB RAM or higher • 8x CD-ROM drive or faster • Adobe® Acrobat® Reader™ with Search 3.0 software (5.0 included on CD-ROM)

Minimum Macintosh® System Requirements
Macintosh® II or above • System 7.0 or later • 8 MB RAM or higher • Adobe® Acrobat® Reader™ with Search 3.0 or higher (Not included on CD-ROM; obtain free at www.adobe.com; see requirements on website)

INSTALLATION FOR WINDOWS® OPERATING SYSTEM
1. Place the CD-ROM in your computer's CD-ROM drive.
2. The Start program should begin automatically. If it does not, double-click the "start.exe" file in the CD's root directory. (Install Acrobat® Reader™ if it is not already available on your computer.)
3. Click "Clip Art for Sundays and Solemnities" to begin navigating the CD-ROM.
4. Click "Clip Art for Sundays and Solemnities Index" to use the Acrobat® Search function.

INSTALLATION FOR MACINTOSH® OPERATING SYSTEM
1. Install Adobe® Acrobat® Reader™ with Search if it is not already available on your computer. (Available at www.adobe.com or on the CD-ROM.)
2. Place the CD in your computer's CD-ROM drive.
3. Double-click the CD icon when it appears on the desktop.
4. Double-click the "Start.pdf" Acrobat® PDF file and navigate from there.
5. Follow the links to open "Clip Art for Sundays and Solemnities" or an explanation of the Acrobat® Search function.

THE ADOBE® ACROBAT® SEARCH FUNCTION
This function allows a user to locate terms in an index created for one or more groups of documents. This CD's index is usable in Acrobat® versions 3 to 5. Be sure you are using a version of the Acrobat® program with Reader™ Search.

The user should open the search engine, load the index, then search for terms. Since Acrobat® versions 3, 4, and 5 differ slightly, the user should consult the explanatory screens on this CD.

HOW TO FIND THE IMAGE YOU WANT
The PDF format allows you to view the images as they appear in the book. It also allows you to search the disc to find the scripture text that accompanies the photos, as well as a particular Sunday or solemnity.

You do not have to view the images in the PDF format to access them. Images are saved in TIFF, JPEG, and GIF formats. They can be found in the "CONTENT" folder that appears when you open the disc (right-click on Clip Art file), and can be copied directly into your program like other TIFF format files.

Image files are named for the page on which they appear in this book and for the Sunday or solemnity that they represent. For example, file 14_LENT_3_A.TIF contains the image on page 14, Lent, week 3, year A.

For Windows® users, this information is available from the Help menu.

LICENSE AND LIMITED WARRANTY
As with the printed pages of this book, this CD-ROM is licensed for exclusive use by the original purchaser. Liturgy Training Publications warrants that the CD-ROM is free from defect in material and workmanship for a period of 30 days from the date of purchase. Defective CDs must be returned to LTP within this warranty period in order to be replaced at no charge. This program is provided "AS IS," and Liturgy Training Publications is in no way liable or responsible for any problems that may arise from its use. This statement shall be construed, interpreted, and governed by the laws of the State of Illinois.

COPYRIGHT
The art on this CD is subject to the same copyright as stated on the acknowledgments page at the front of this book.